TRADITIONAL AFRICAN DESIGNS

Gregory Mirow

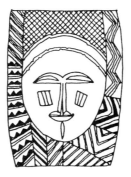

DOVER PUBLICATIONS, INC.
Mineola, New York

Copyright

Copyright © 1997 by Dover Publications, Inc.
All rights reserved under Pan American and International Copyright Conventions.

Bibliographical Note

Traditional African Designs is a new work, first published by Dover Publications, Inc., in 1997.

DOVER *Pictorial Archive* SERIES

This book belongs to the Dover Pictorial Archive Series. You may use the designs and illustrations for graphics and crafts applications, free and without special permission, provided that you include no more than ten in the same publication or project. (For permission for additional use, please write to: Permissions Department, Dover Publications, Inc., 31 East 2nd Street, Mineola, N.Y. 11501.)

However, republication or reproduction of any illustration by any other graphic service, whether it be in a book or in any other design resource, is strictly prohibited.

Library of Congress Cataloging-in-Publication Data

Mirow, Gregory.
 Traditional African designs / Gregory Mirow.
 p. cm. — (Dover design library) (Dover pictorial archive series)
 ISBN 0-486-29622-9 (pbk.)
 1. Decoration and ornament—Africa, Sub-Saharan. 2. Art, Black—Africa, Sub-Saharan.
I. Title. II. Series. III. Series: Dover pictorial archive series.
NK1488.75.M57 1997
745.4'4967—dc21 96-29852
 CIP

Manufactured in the United States of America
Dover Publications, Inc., 31 East 2nd Street, Mineola, N.Y. 11501

PUBLISHER'S NOTE

THE DISTINCTIVE African style of art, apparent in pottery, sculpture and cloth designs, represents the various spiritual customs and values of each tribe. European views on art, often emphasizing aesthetic beauty or symmetry, do not always apply in the appreciation of African art. The religious and cultural beliefs of each tribe are so enmeshed with the art of Africa that the two become virtually inseparable.

The creation of a work of art is often inspired by the African belief system. In many instances, the art is created for the ancestor spirits, as African culture revolves around the idea that the ancestors have power over the lives of their direct descendants. For example, among the Yoruba tribe of Nigeria, the ancestral spirit known as the *egungun* has supernatural powers. Through the medium of art, African secret societies pay homage to their ancestors. The living are dependent on their ancestors for the future of the tribe and strive to please their spirits through art, music and ceremonial activities. The *chi wara*, depicted on page 4 and usually shown in the form of an antelope, represents the spirit who first introduced agriculture to the Bambara tribe of Mali. Artwork from Burkina Faso representing the deity Do is used in tribal requests for rain and fertility during harvest season.

Many of the symbols in the designs found on cloths, murals and sculpture have an intrinsic meaning. These can represent local proverbs or stature in society. Much of African art is an expression of lineage and kinship relationships. Different motifs in cloth designs often reflect the tribal member's rank in society. In this way, the wearer of a certain piece of clothing conveys a message to the rest of his tribal members. A highly respected elder in the tribe, for example, will wear a design different from that borne by any other member of the group.

This collection of over 200 African designs is representative of tribal art in such nations as: Nigeria, Mali, Ghana, Côte d'Ivoire (Ivory Coast), Burkina Faso (formerly Upper Volta), and Sierra Leone. Through artistic geometric patterns, stylized animals and decorative abstractions, the African artist provides a direct link to the mysticism of the spirits.

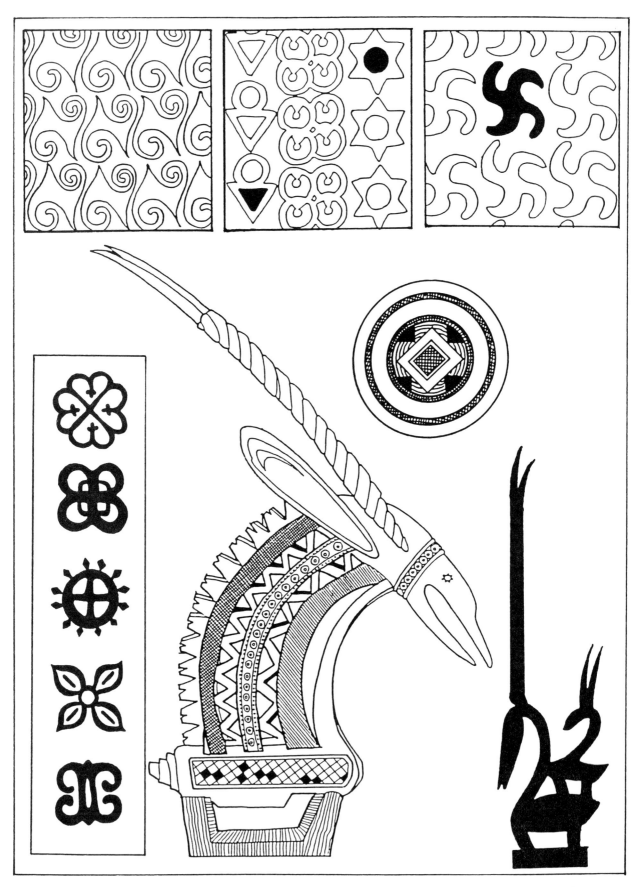

TOP: Adinkra cloth, Ashanti people, Ghana. MIDDLE, RIGHT: Calabash lid, Dahomey people, Benin. BOTTOM, LEFT: Ashanti motifs. BOTTOM, MIDDLE: Male *chi wara*, Bambara people, Mali. BOTTOM, RIGHT: Female *chi wara*, Bambara, Mali.

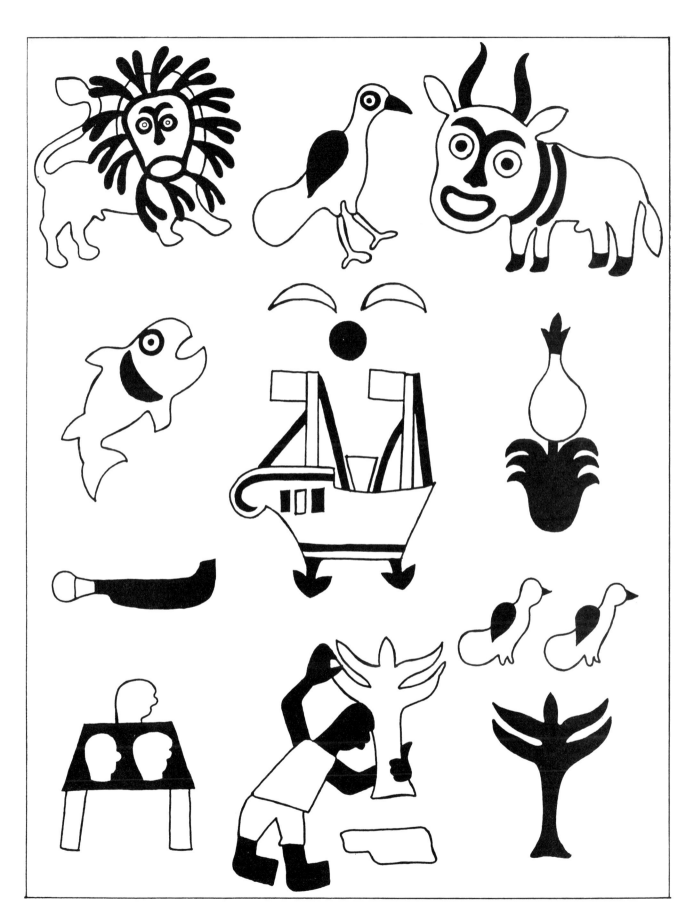

Dahomey appliqué cloth, Benin.

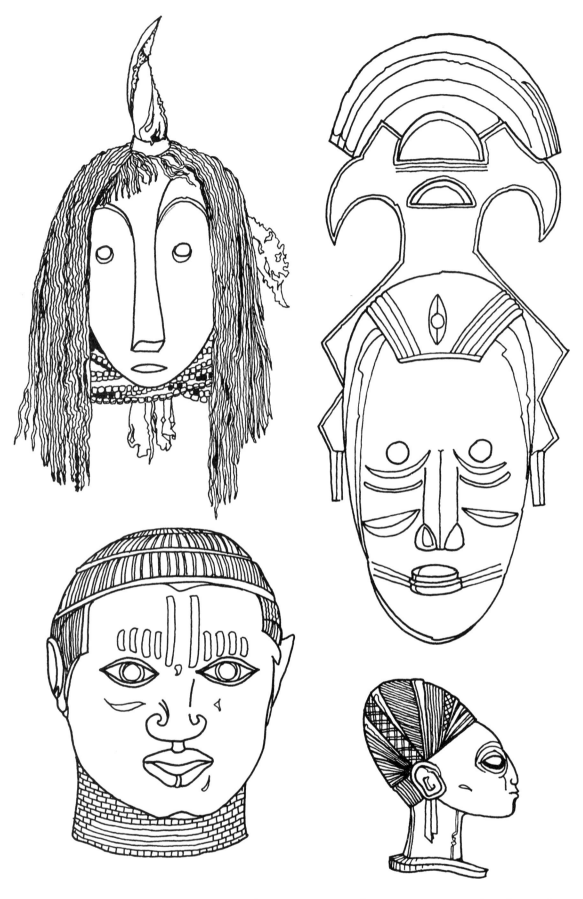

Masks. TOP, LEFT: Fetish, eastern Bapende or Basonge people, Zaire. TOP, RIGHT: Senufo people, Côte d'Ivoire. BOTTOM, LEFT: Ife people, Benin. BOTTOM, RIGHT: Yoruba people, Nigeria.

Interior wall and pillar decorations, Mangbetu people, Zaire.

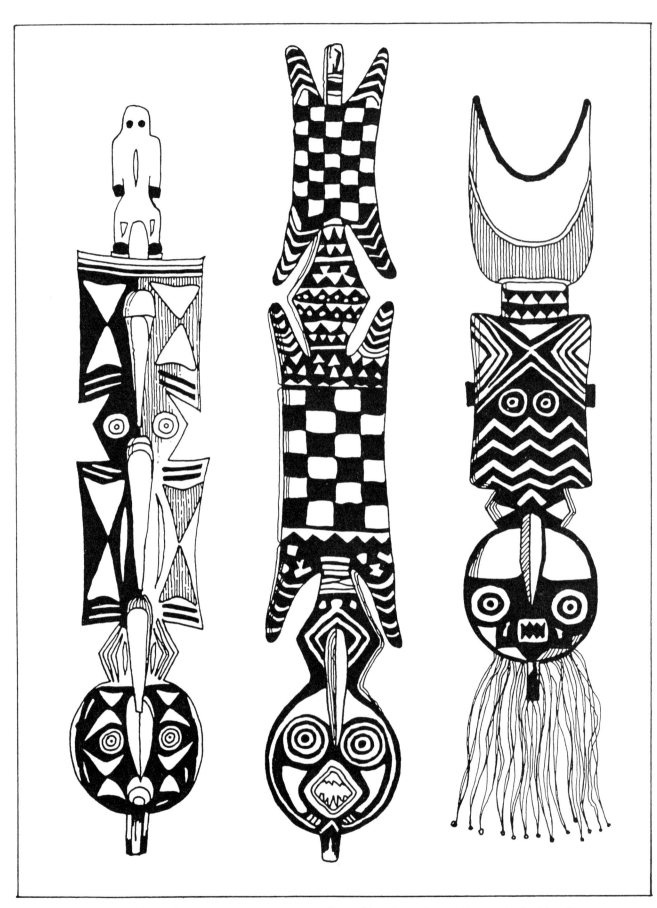

LEFT: Do mask, Burkina Faso. MIDDLE: Bwa mask, Burkina Faso. RIGHT: Do mask, Burkina Faso.

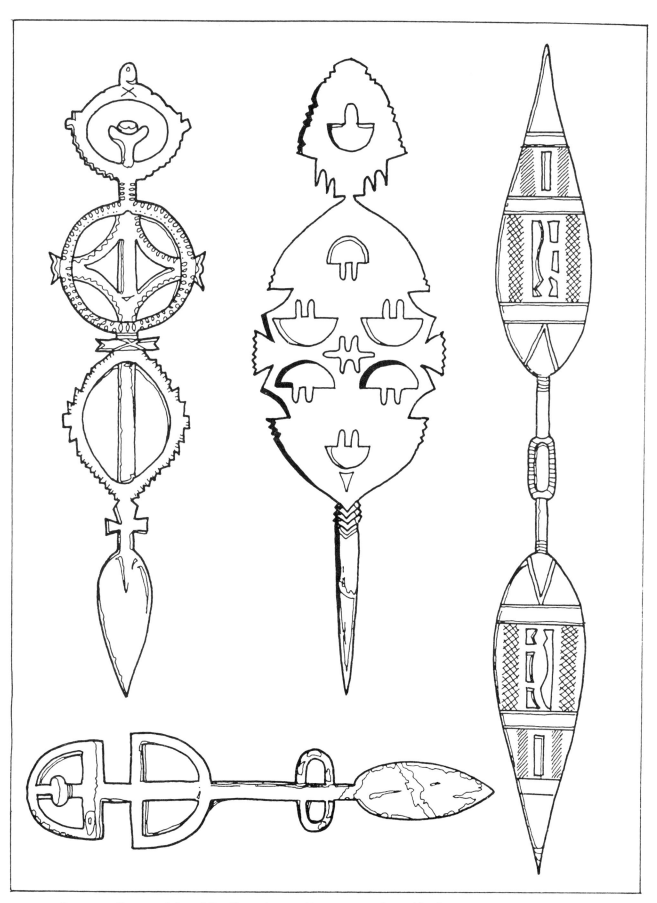

TOP, LEFT: Ceremonial paddle, Sierra Leone. TOP, MIDDLE: Carved bedpost, Tuareg people, Algeria. TOP, RIGHT, AND LOWER LEFT: Ceremonial paddles, Ijaw people, Sierra Leone.

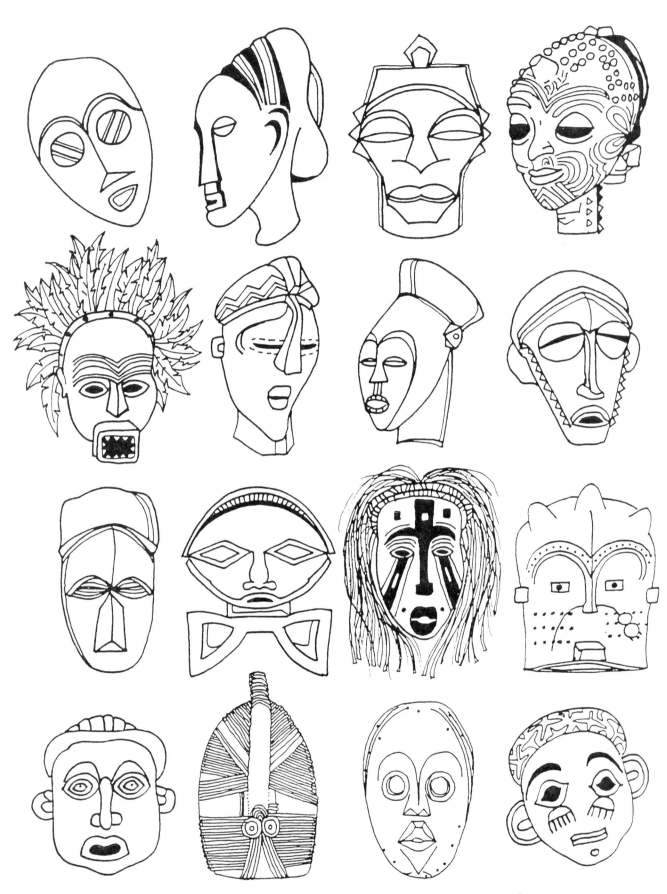

Masks. ROW 1, LEFT TO RIGHT: Maluga, Bahemba, Basonge and Bena Lulua peoples. ROW 2, LEFT TO RIGHT: Masubiya, Balolo, Bambole and Wabembe. ROW 3, LEFT TO RIGHT: Bawoyo, Bahuana, Bavila and Pangwe. ROW 4, LEFT TO RIGHT: Bekom, Bakota, Dan and Baum.

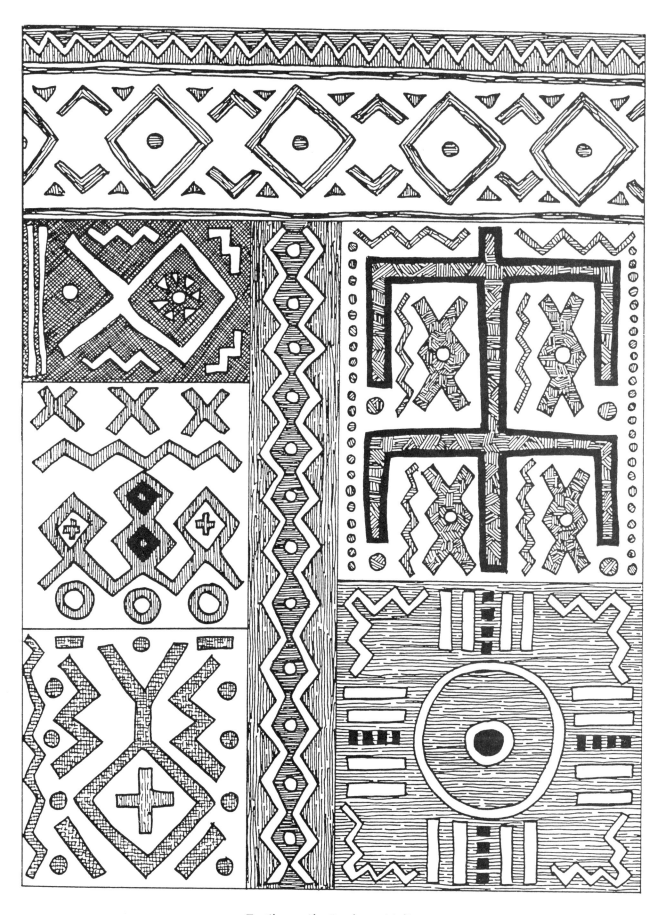

Textile motifs, Bambara, Mali.

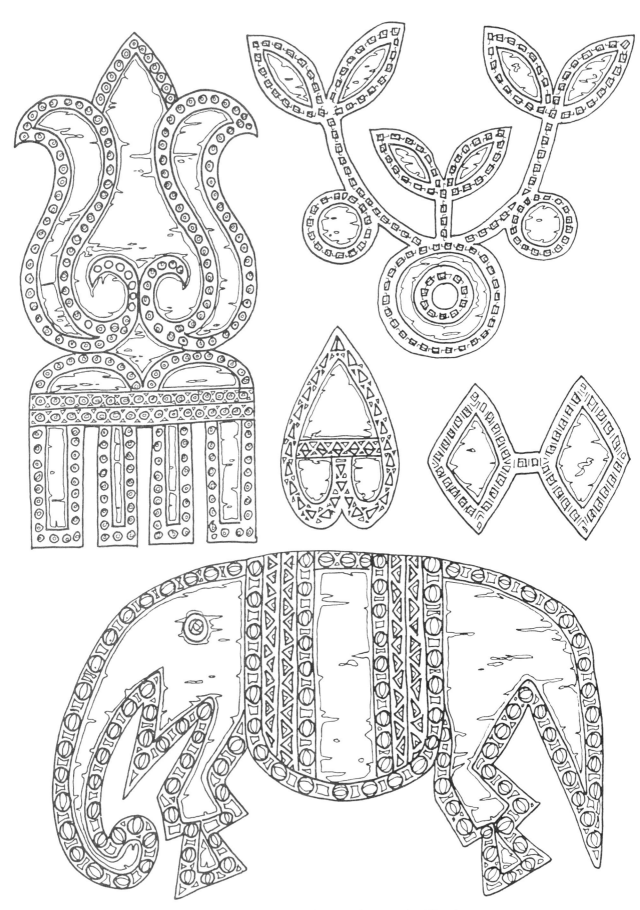

Motifs from leather fans, Ogbe people, Nigeria.

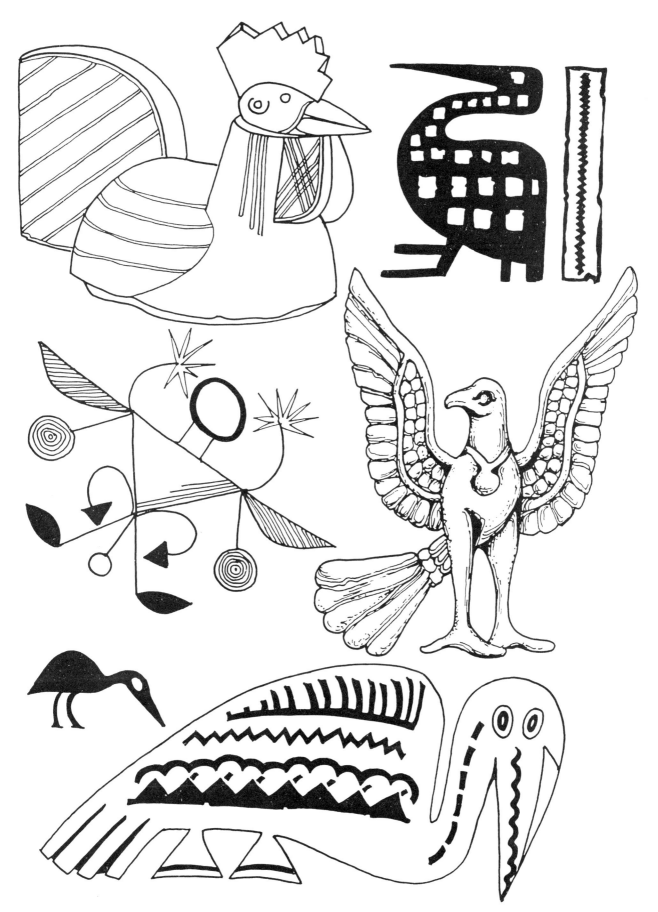

TOP, LEFT: Yoruba, Nigeria. TOP, RIGHT: Hansa calabash. MIDDLE, LEFT: Hansa calabash. MIDDLE, RIGHT: Sudan. BOTTOM, LEFT AND RIGHT: Hansa.

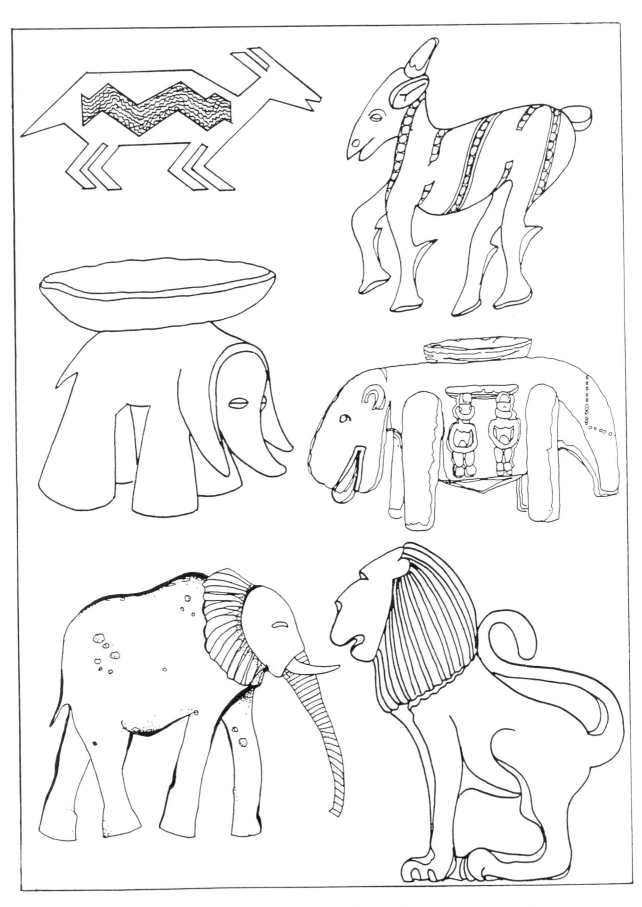

TOP, LEFT: Zaire. TOP, RIGHT: Benin. MIDDLE, LEFT: Baluba stool, Zaire. MIDDLE, RIGHT: Dogon people, Mali. BOTTOM, LEFT: Bardi, eastern Sahara Desert. BOTTOM, RIGHT: Ashanti, Ghana.

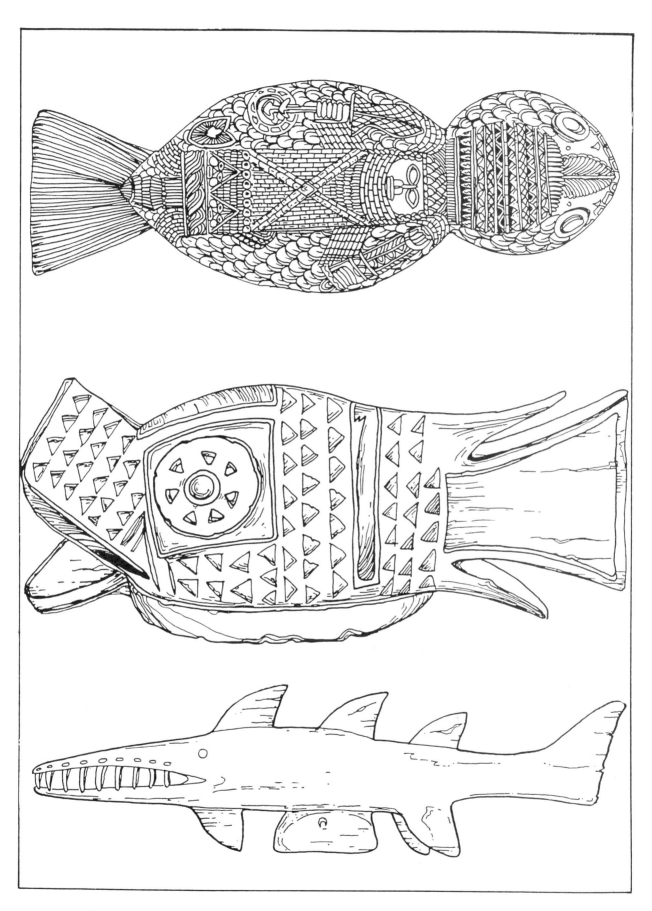

TOP: Benin. MIDDLE: Bobo fish mask, Burkina Faso. BOTTOM: Wooden shark mask, Ijaw, Sierra Leone.

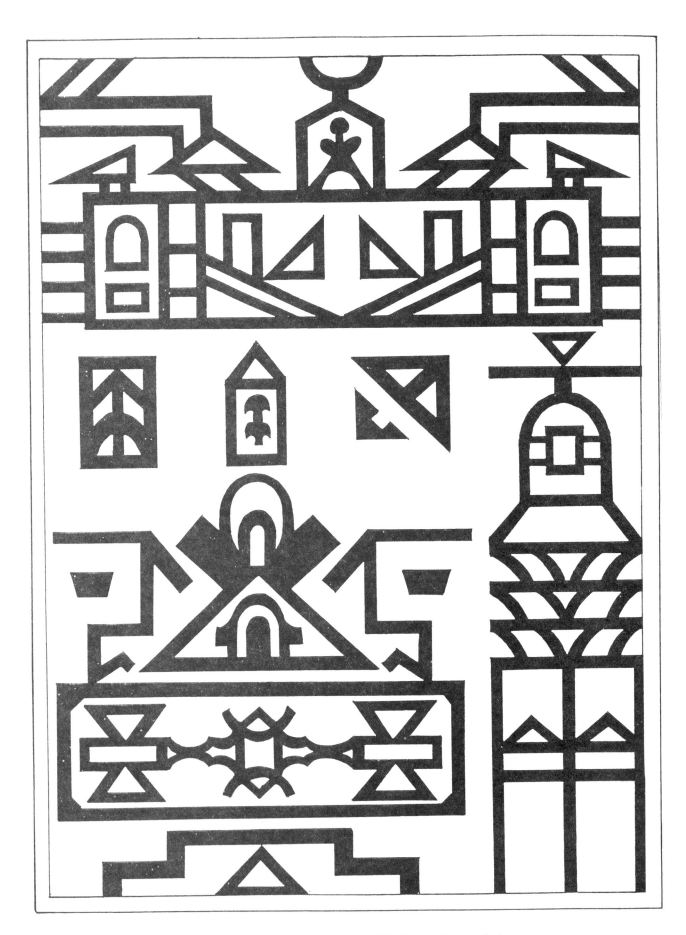

Exterior house decorations (details), Ndebele people, Zimbabwe.

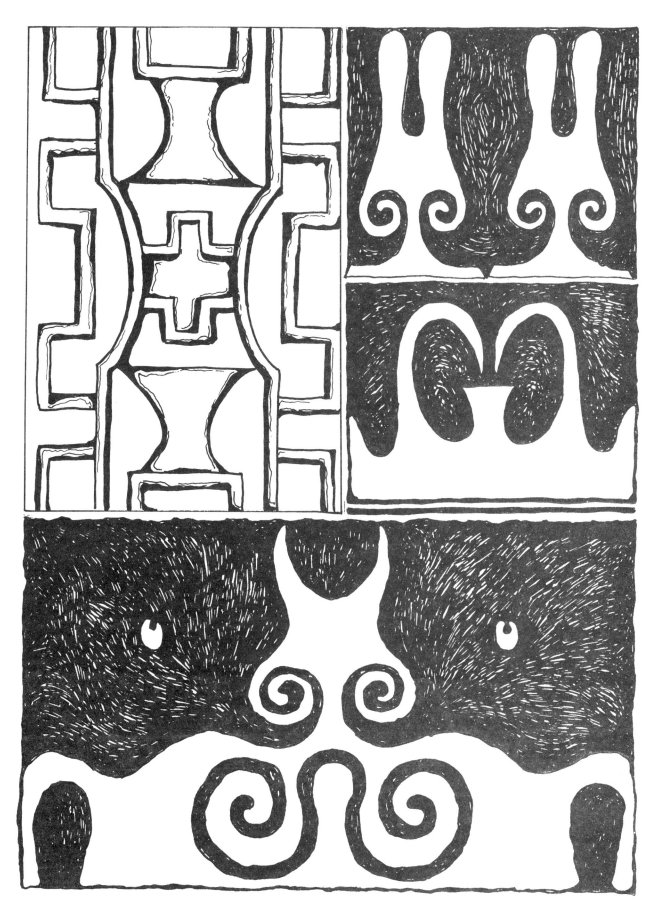

Wall paintings from Nilotic and central Sudanese dwellings, Sudan.

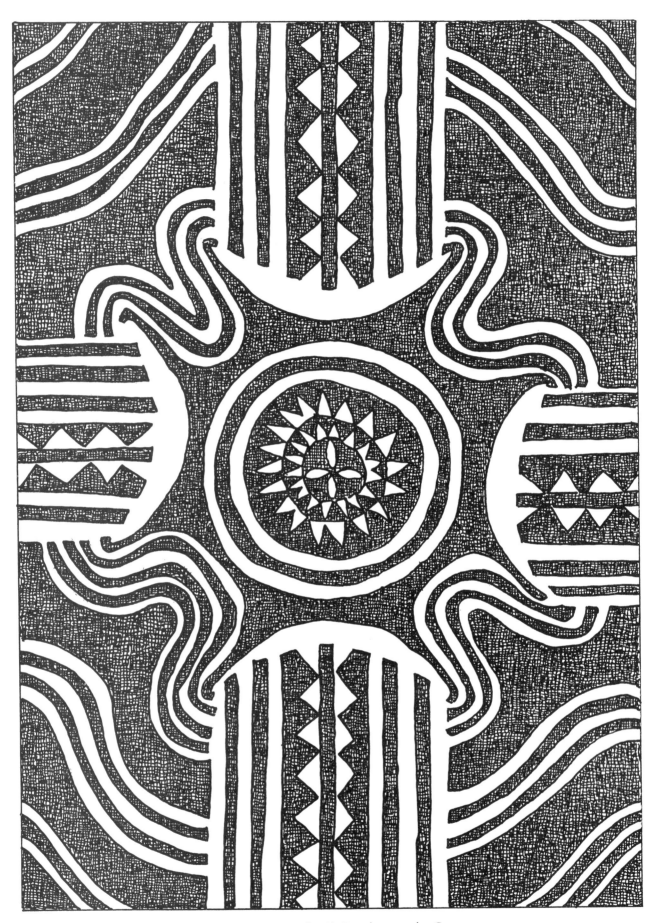

Wall decoration detail, Bangba people, Congo.

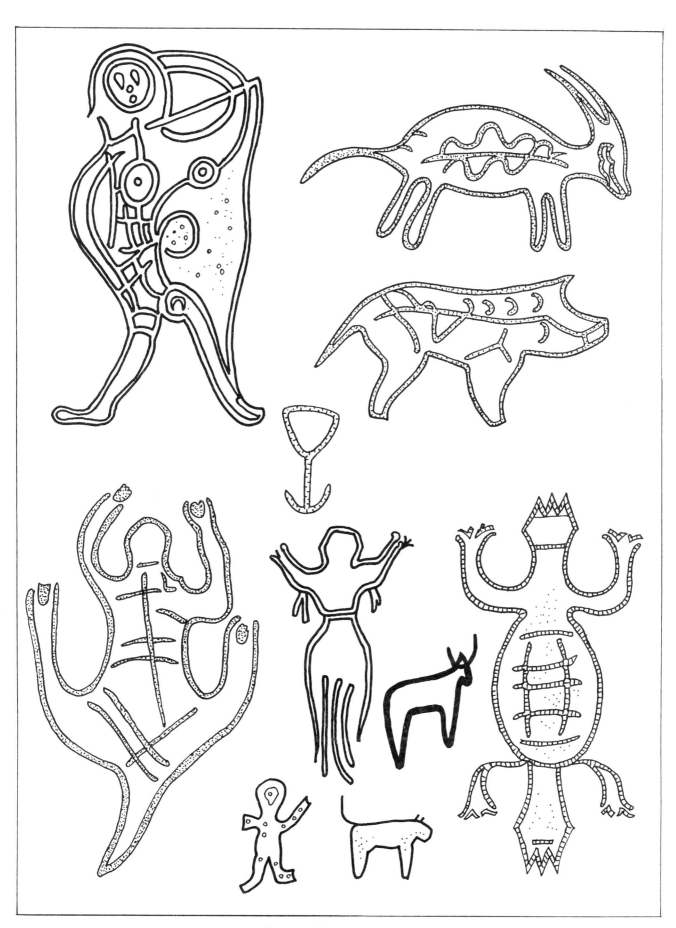

Inygo figures of the Wayao of Malawi.

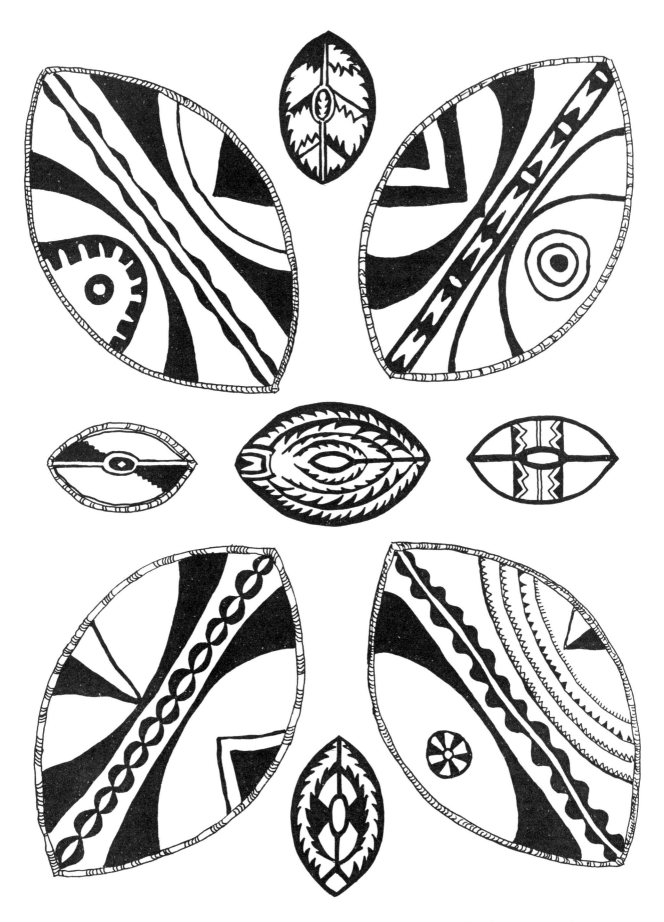

Small shields for ceremonial dances of Kikuyu youths, Kenya; large shields for Kenya warriors.

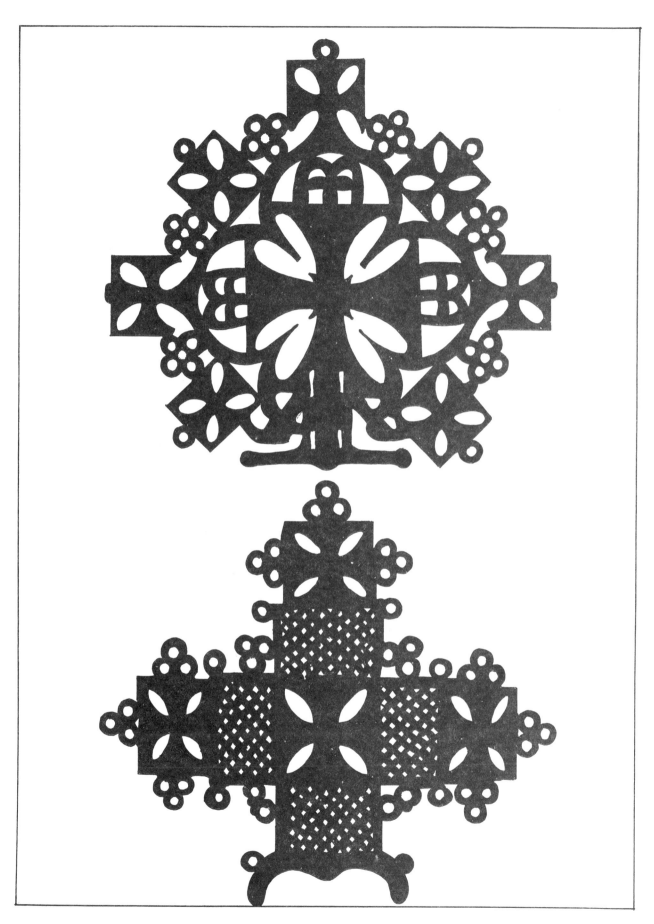

Ethiopian crosses.

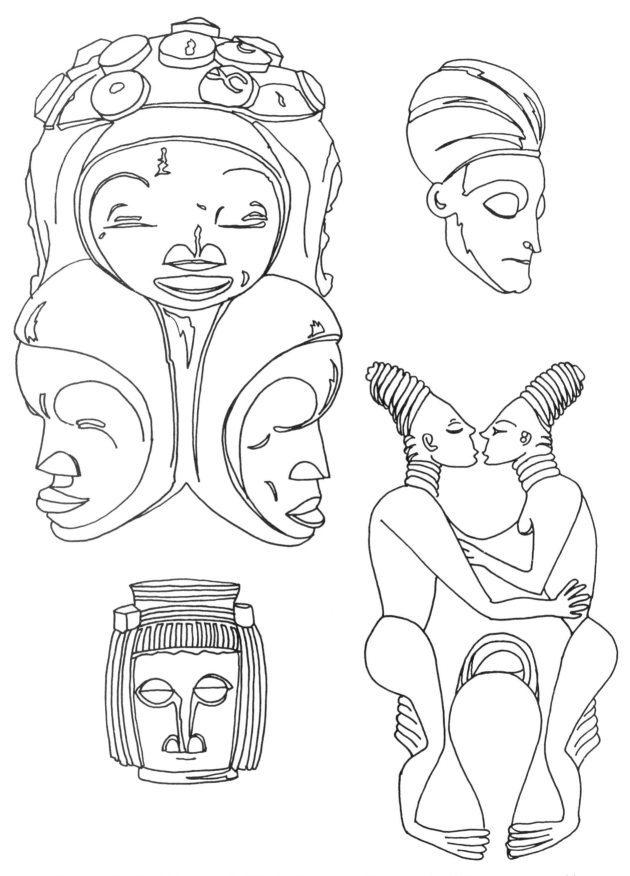

TOP, LEFT: Detail of Idoma mask, Nigeria. TOP, RIGHT: Cameroon head. BOTTOM, LEFT: Gold-plated sculpture, Baule people, Côte d'Ivoire. BOTTOM, RIGHT: Ivory spatula detail, Mangbetu, Zaire.

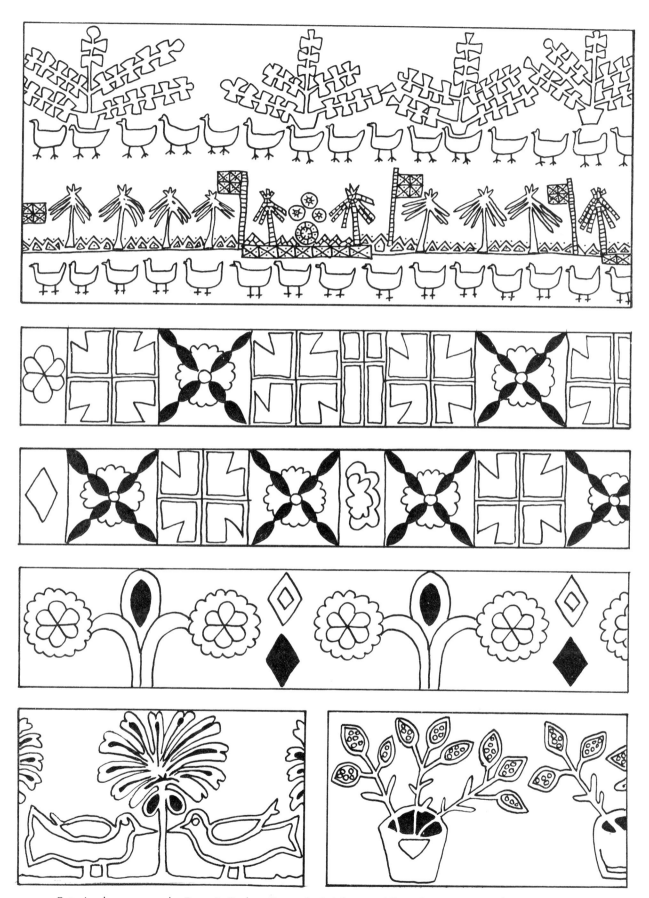

Exterior house murals. ROW 1: Sudan. ROWS 2–4: Niamey, Niger. BOTTOM, LEFT: Shaturma. BOTTOM, RIGHT: Wadi-al-Arab.

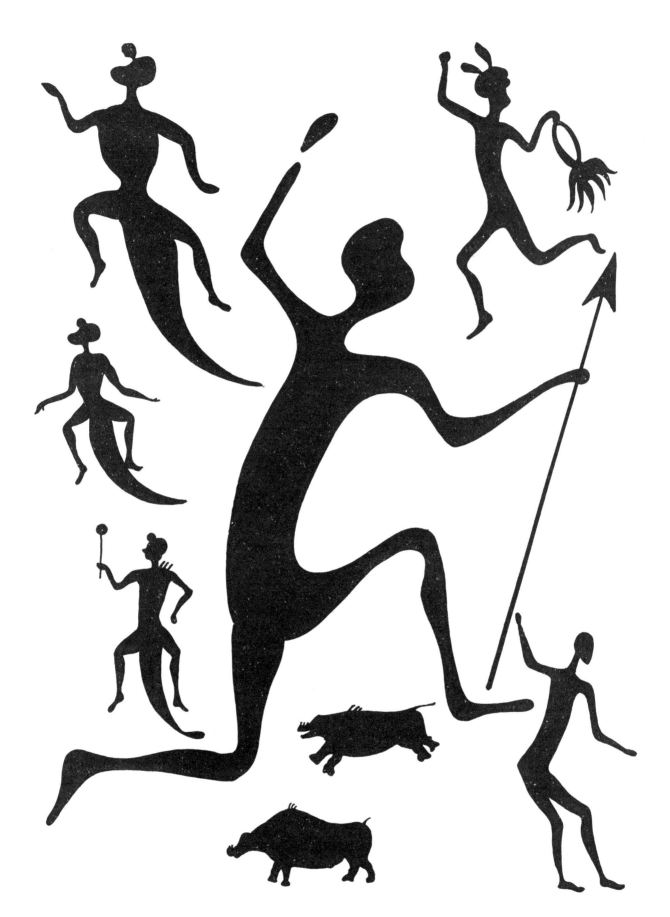

South African cave paintings.

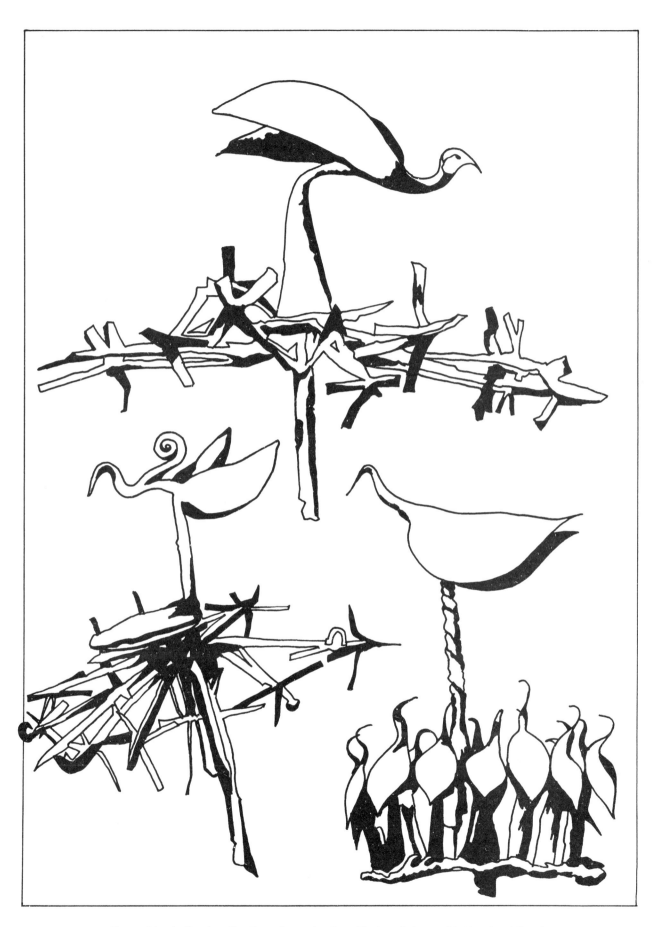

Tops of herbalists' staffs, Opa Osanyin Osunifa (medicine cult), Yoruba, Nigeria.

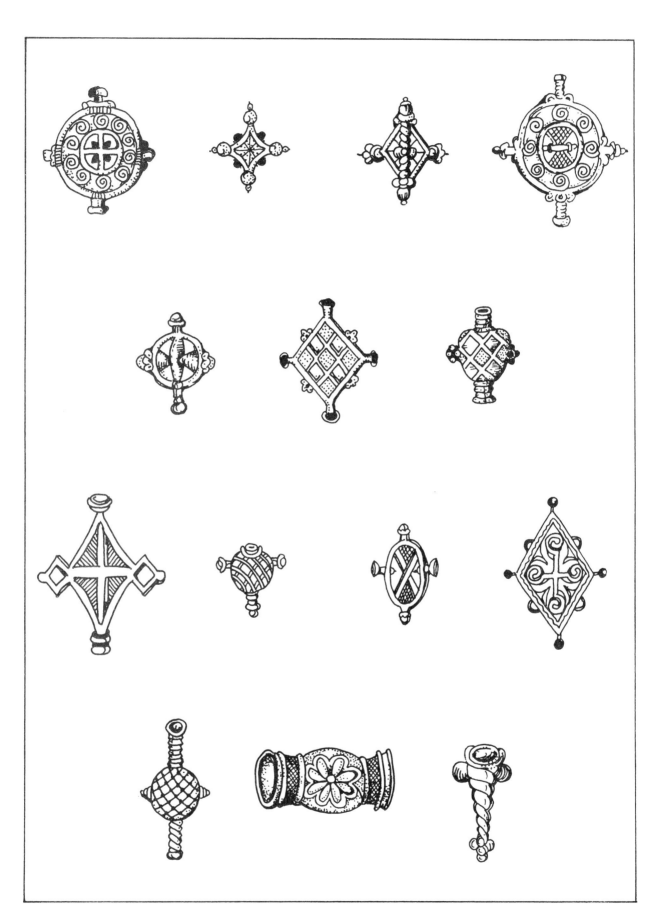

Akan jewelry beads, Ashanti, Ghana.

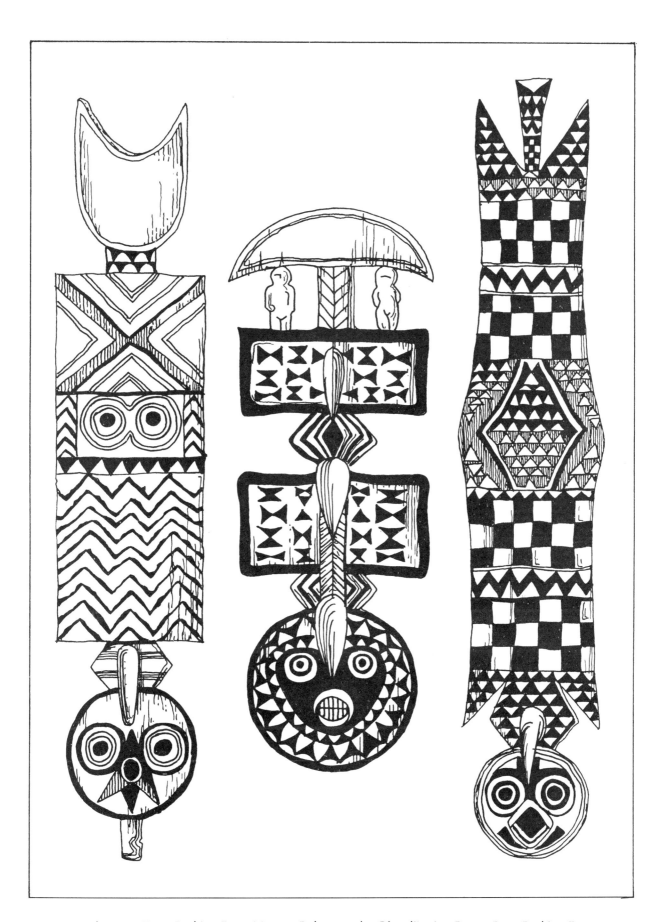

Masks. LEFT: Bwa, Burkina Faso. MIDDLE: Bobo people, Côte d'Ivoire. RIGHT: Bwa, Burkina Faso.

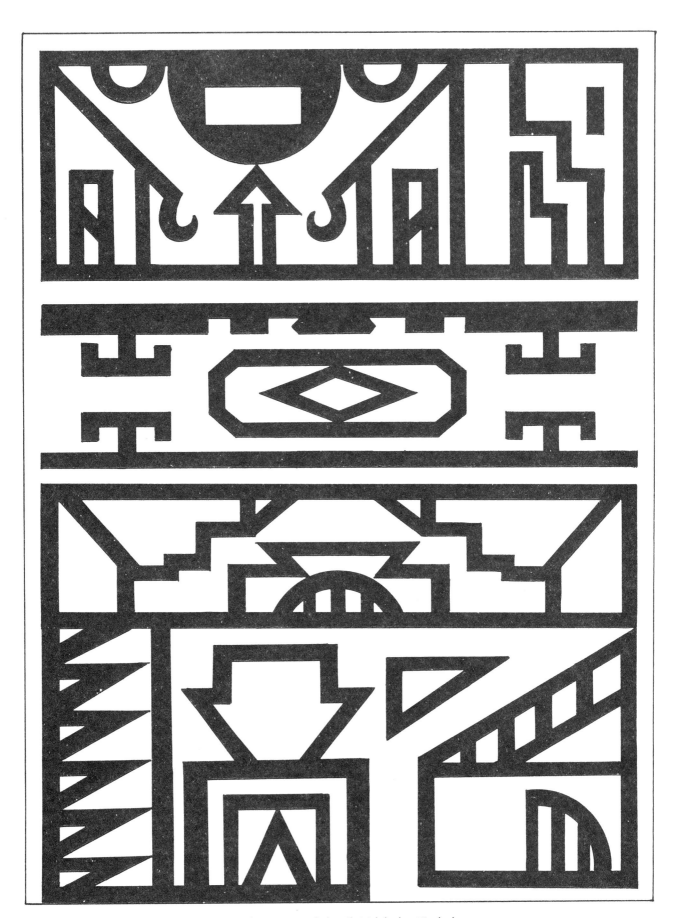

Exterior house mural detail, Ndebele, Zimbabwe.

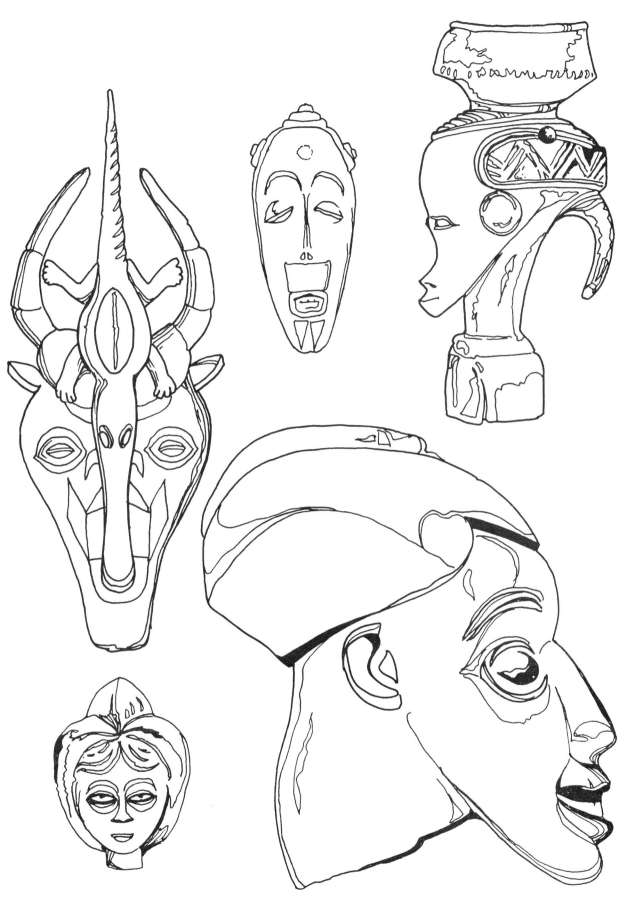

Masks. TOP, LEFT: Aku, Cameroon. TOP, MIDDLE: Benin. TOP, RIGHT: Kom style. BOTTOM, LEFT: Kom.
BOTTOM, RIGHT: Northwest Angola.

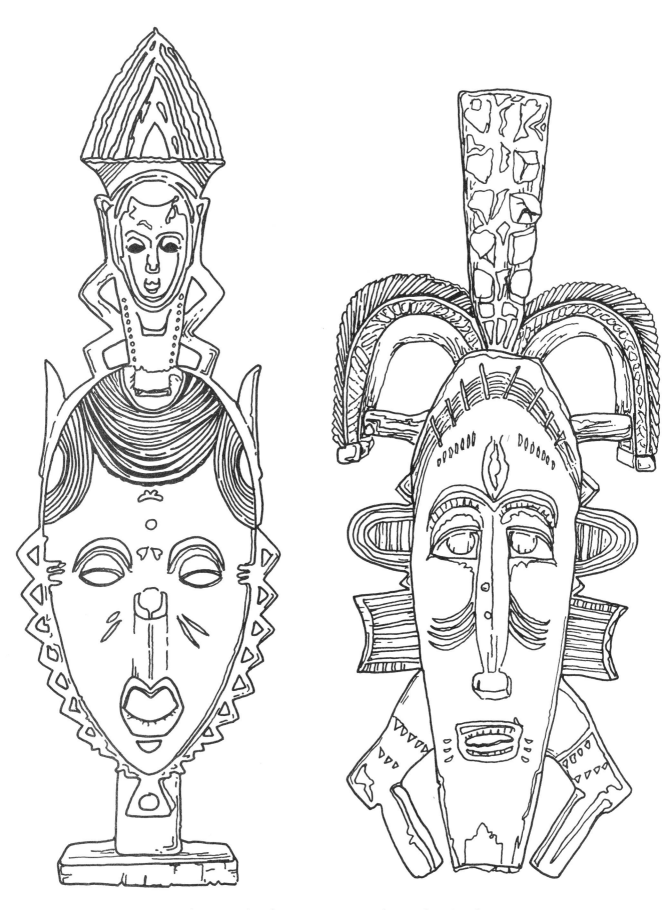

Masks. LEFT: Côte d'Ivoire. RIGHT: Senufo people, Côte d'Ivoire.

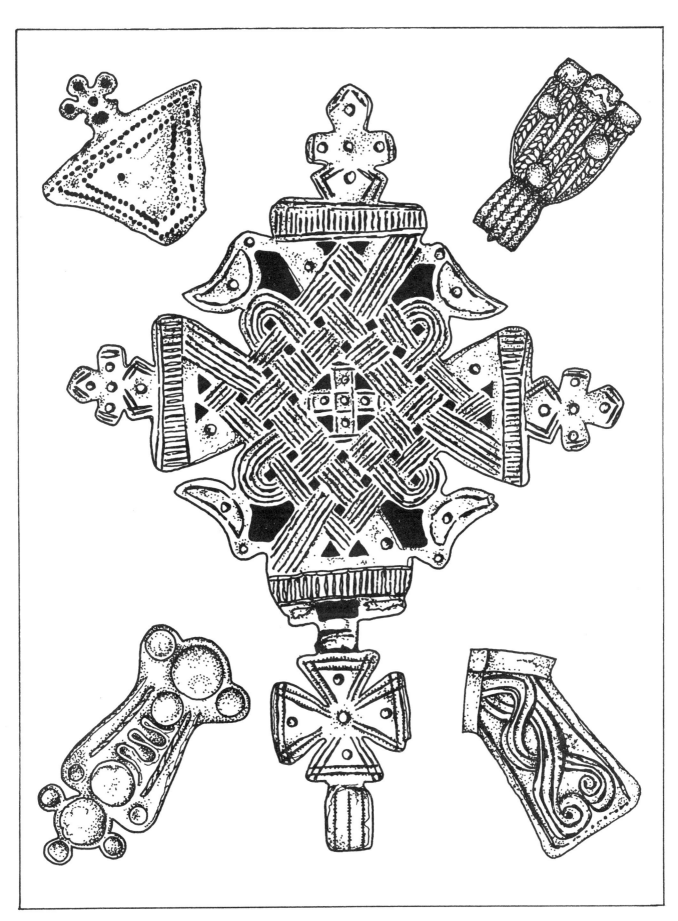

Ethiopian cross and four details.

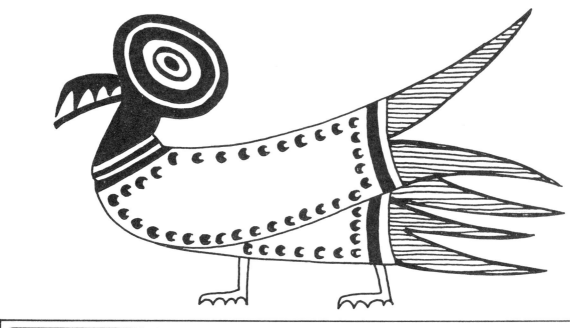

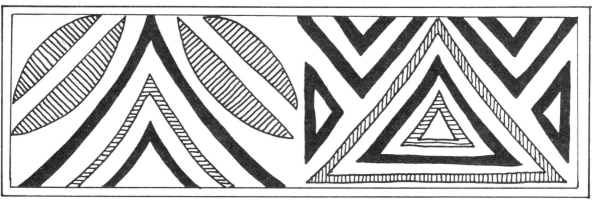

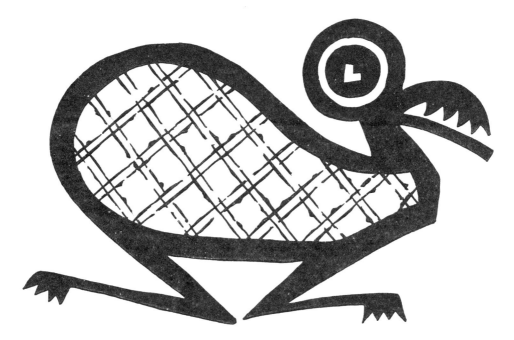

Details of gourd bowls, Ghana.

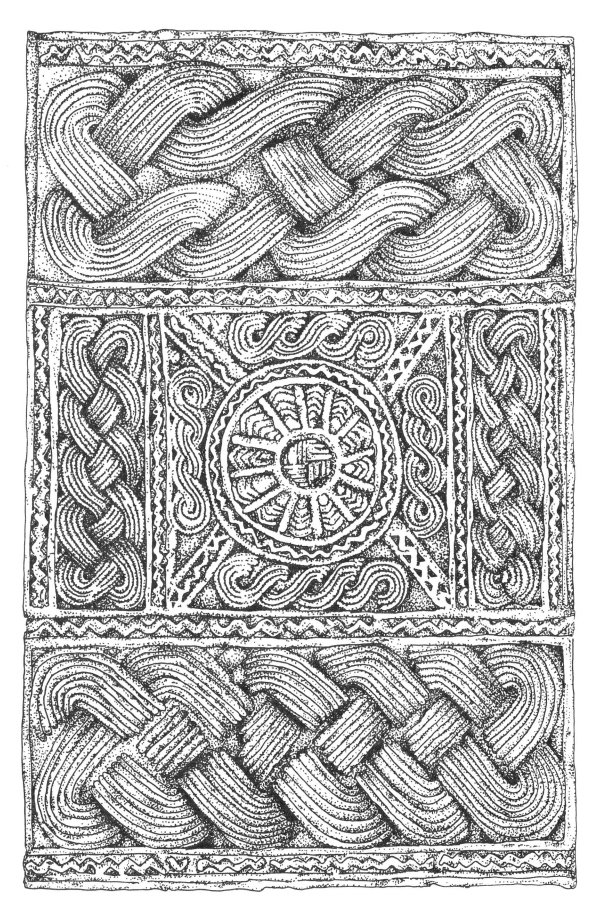

Carved wood panel, Benin.

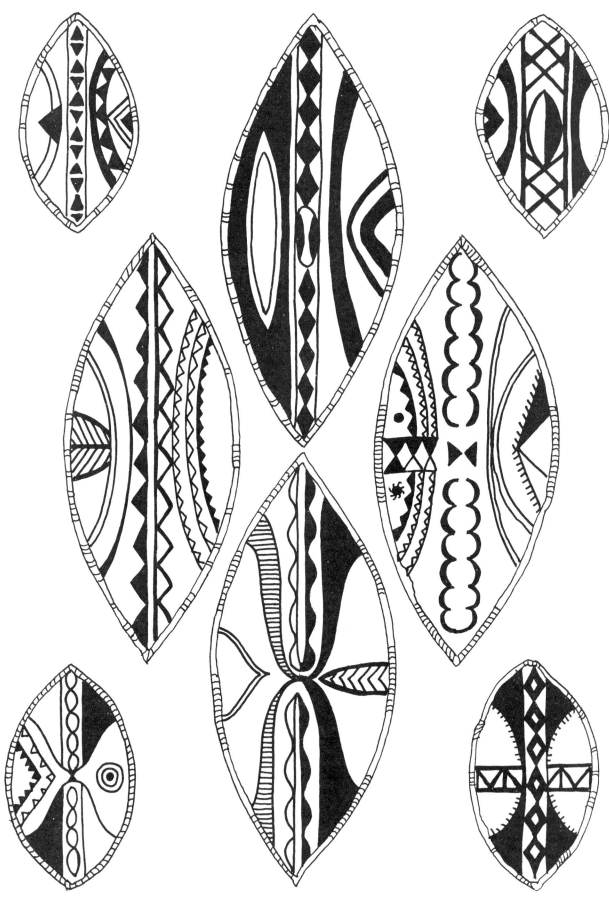

Masai shields, Kenya.

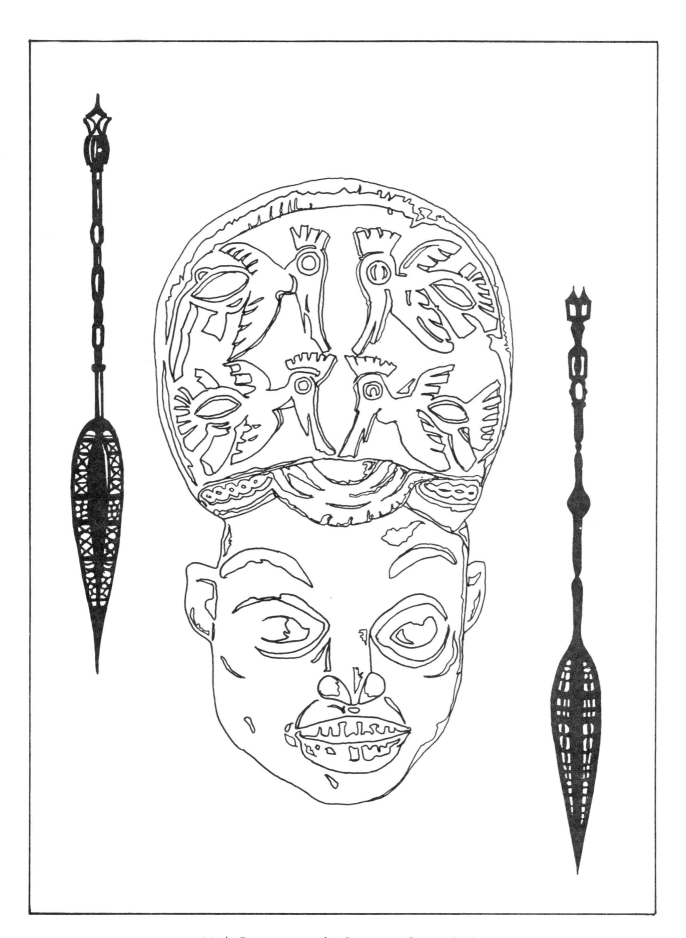

Mask, Bamungo people, Cameroon. Spears, Benin.

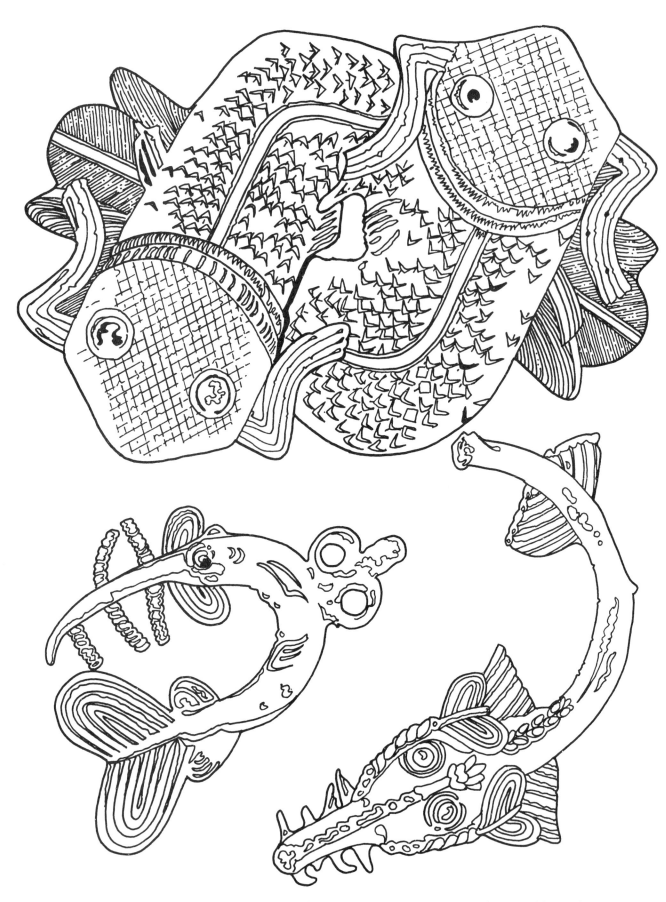

TOP: Bronze stool with interwoven mudfish, Nigeria. BOTTOM: Ashanti brass gold weights, Ghana.

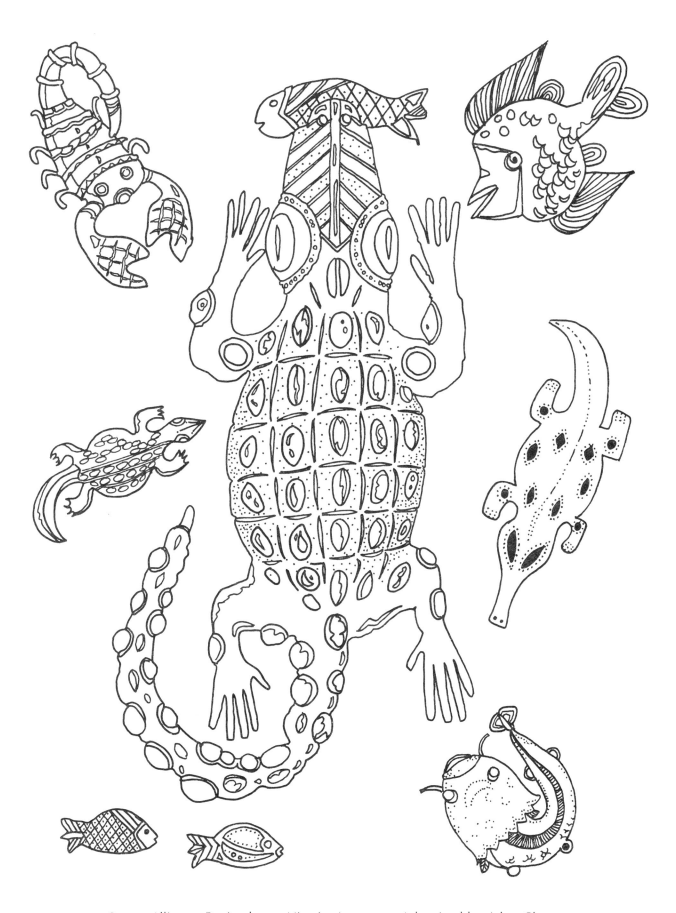

CENTER: Alligator, Benin plaque, Nigeria. ALL OTHERS: Ashanti gold weights, Ghana.

Mural detail, Mangbetu, Zaire.

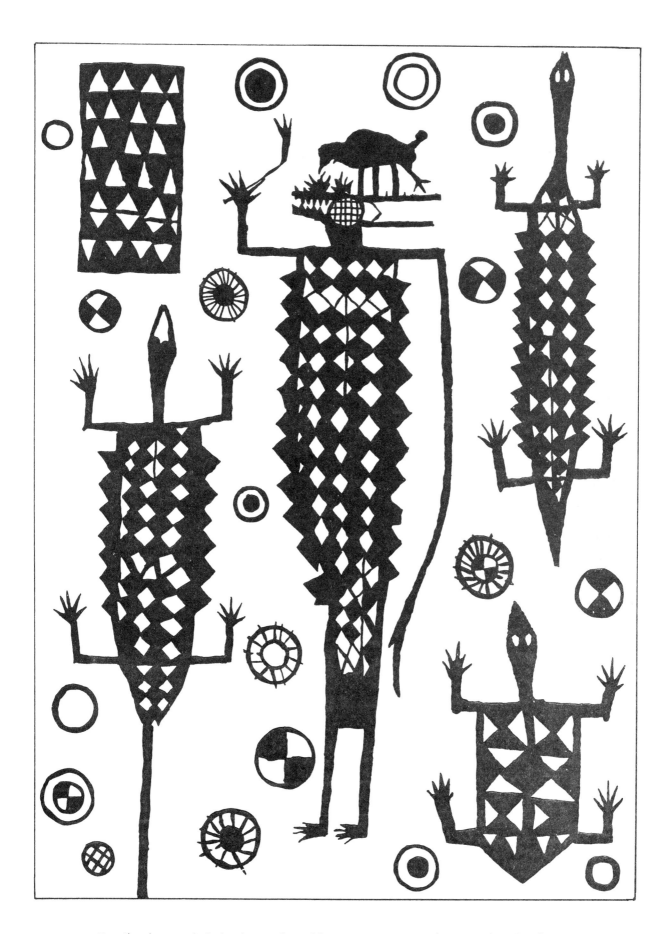

Details of painted cloth of animals and fire-spitter masqueraders, Senufo, Côte d'Ivoire.

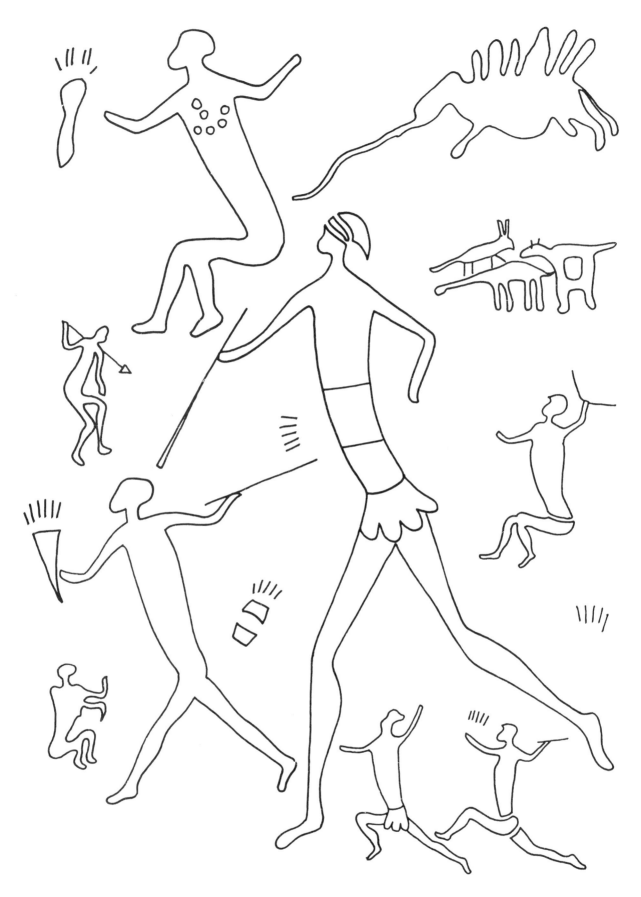

Rock paintings from caves in North Africa.

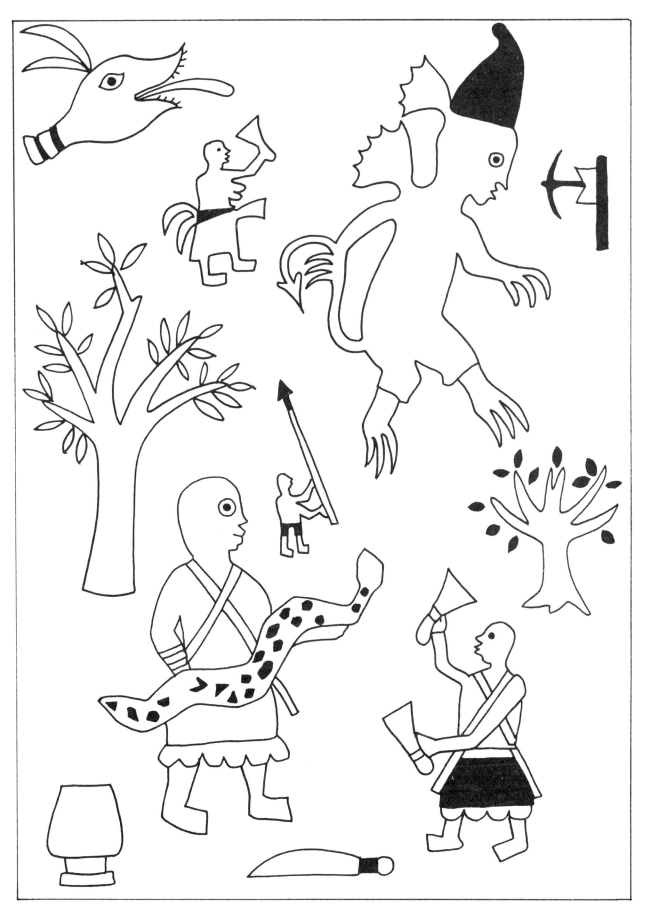

Dahomey appliqués, Benin.

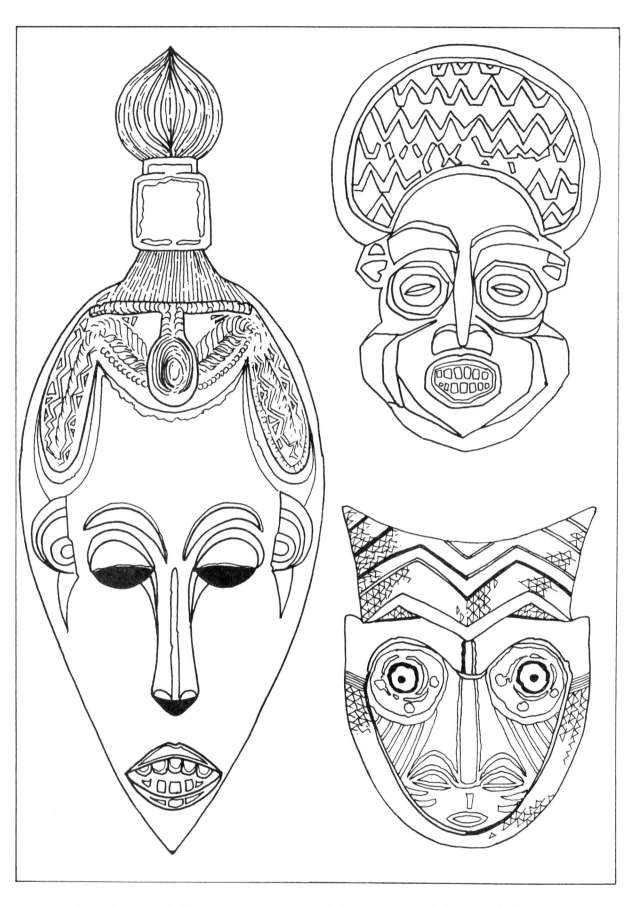

LEFT: Congo mask. TOP, RIGHT: Cameroon mask. BOTTOM, RIGHT: Bakuba mask, Congo.

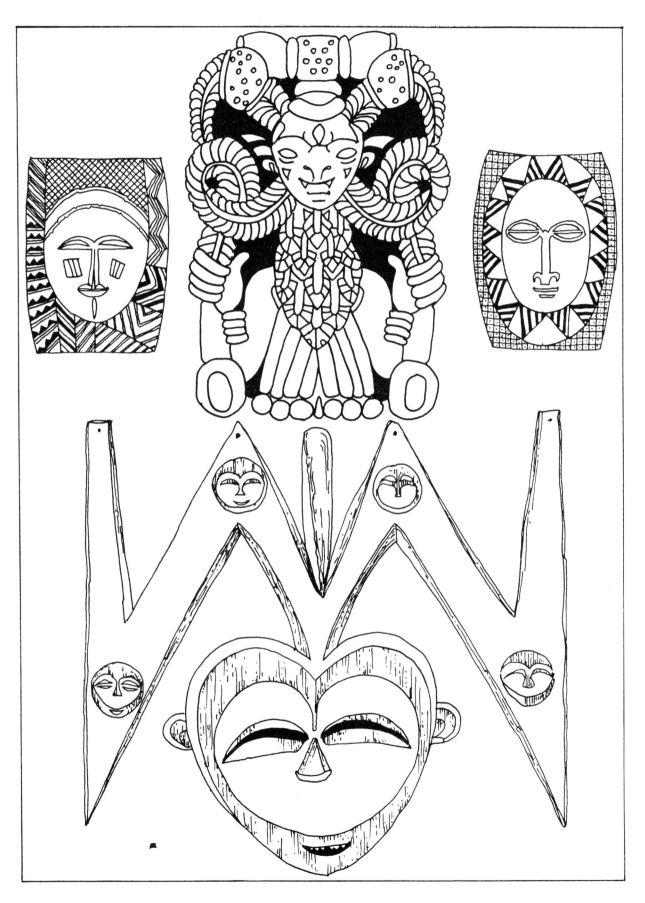

TOP, LEFT AND RIGHT: Baule designs for gold-plated objects, Côte d'Ivoire. TOP, MIDDLE: Carved detail, Côte d'Ivoire. BOTTOM: Brazzaville mask, Congo.

43

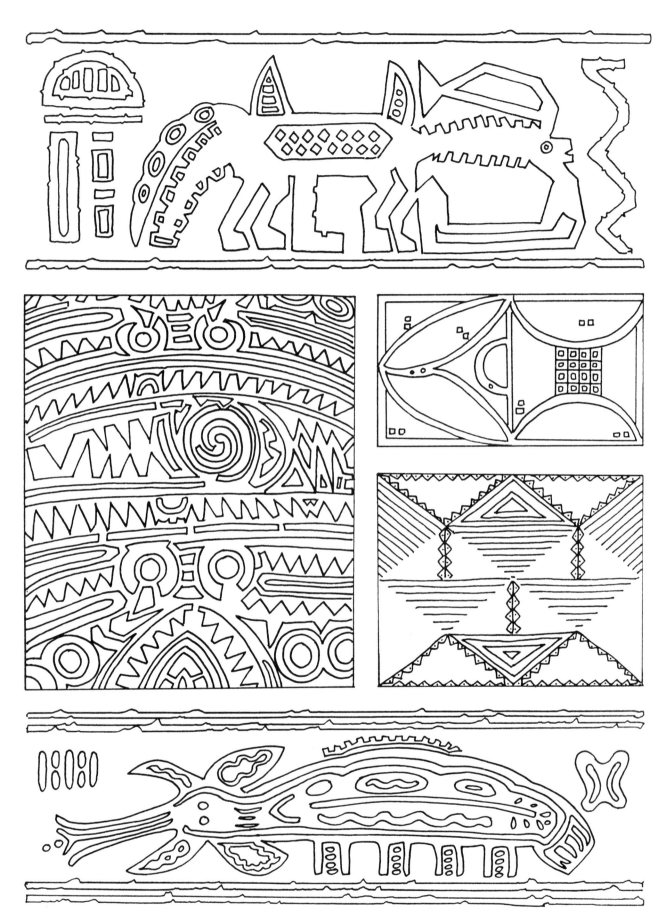

Details from gourd designs, Nigeria.

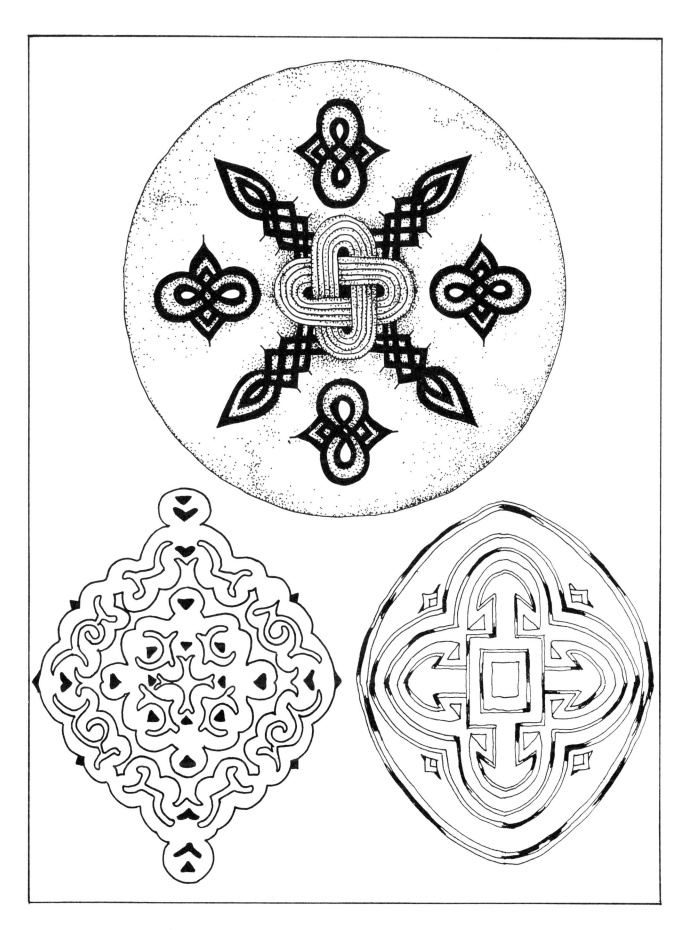

TOP: Cotton cloth, Baule, Côte d'Ivoire. BOTTOM: Doorway decorations, Oualata, Mauritania.

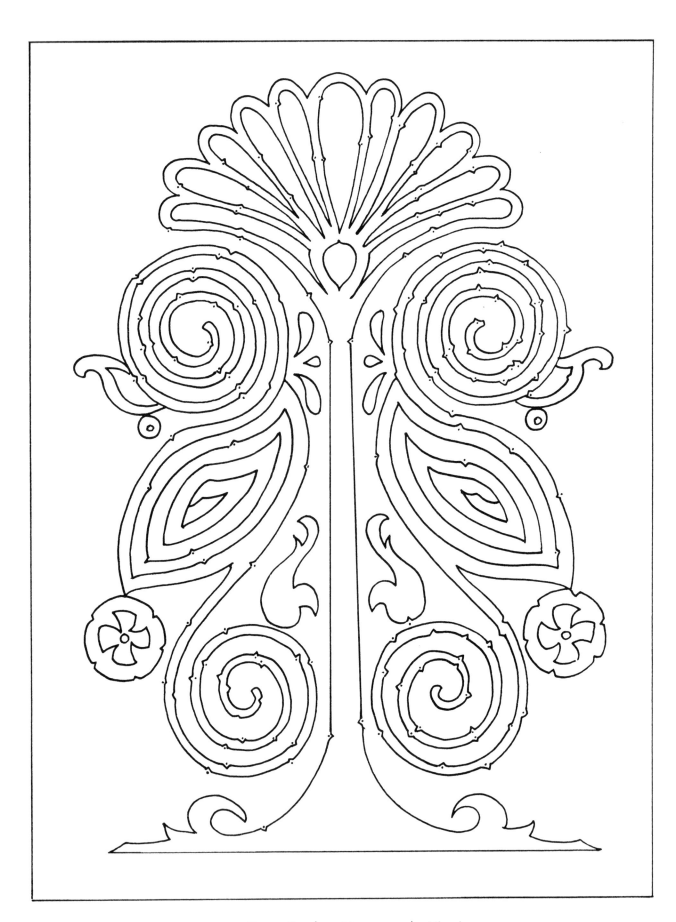

Decoration from Hausa people, Nigeria.

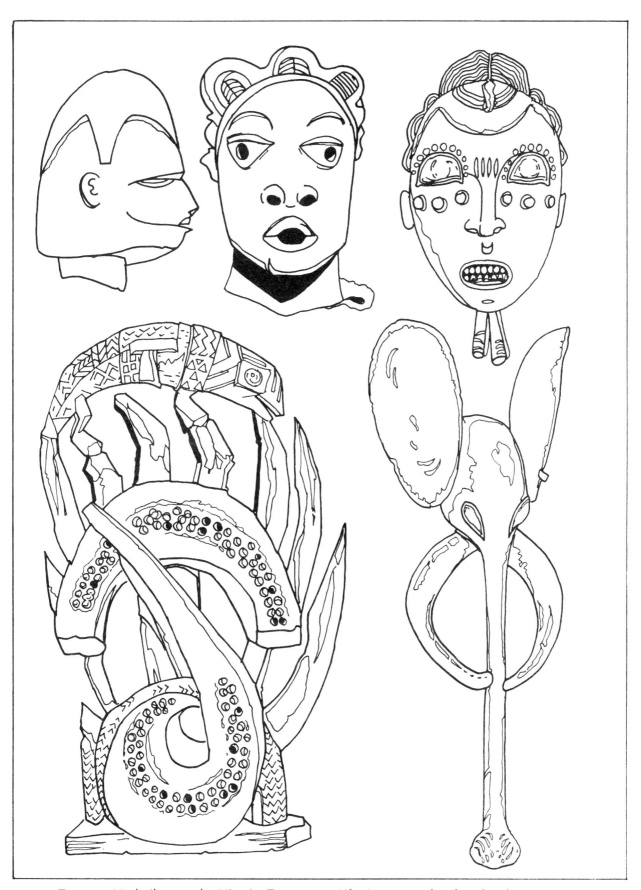

TOP, LEFT: Mask, Ibo people, Nigeria. TOP, MIDDLE: Life-size pottery head, Nok culture, Nigeria. TOP, RIGHT: Mask, Congo. BOTTOM, LEFT: Yoruba headdress, Nigeria. BOTTOM, RIGHT: Cameroon elephant mask.

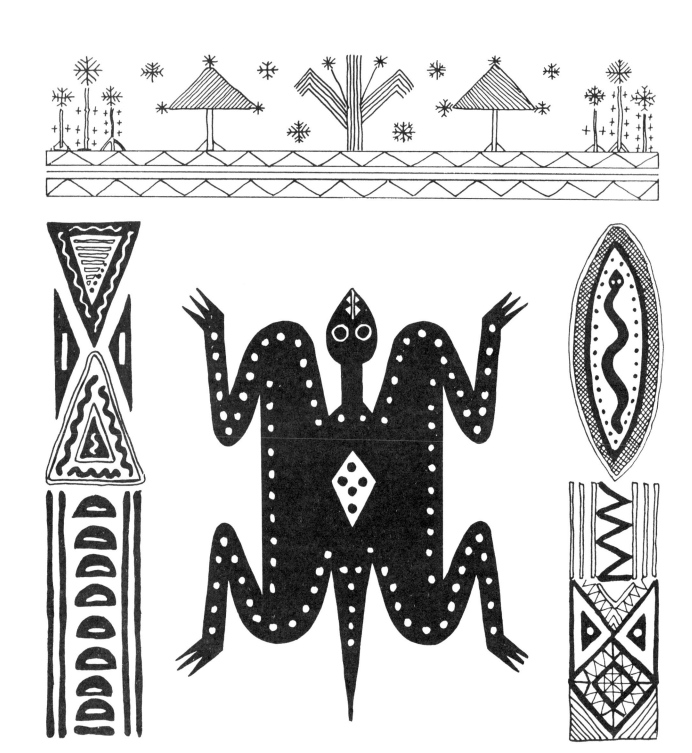

Gourd designs.